MW01029676

RAY BRADBURY
the *homecoming*
illustrated by DAVE McKEAN

the homecoming

Text Copyright © 2006 by Ray Bradbury
Illustration Copyright © 2006 by Dave McKean

HarperCollins books may be purchased for educational, business, or sales promotional use. For information, please write: Special Markets Department, HarperCollins Publishers, 10 East 53rd Street, New York, NY 10022.

First Edition

First published in 2006 by:
Collins Design
An Imprint of HarperCollins*Publishers*
10 East 53rd Street
New York, NY 10022
Tel: (212) 207-7000
Fax: (212) 207-7654
collinsdesign@harpercollins.com
www.harpercollins.com

Distributed throughout the world by:
HarperCollins*Publishers*
10 East 53rd Street
New York, NY 10022
Fax: (212) 207-7654

Book design by Dave McKean @ Hourglass

Library of Congress Control Number: 2006925208

ISBN-10: 0-06-085962-8
ISBN-13: 978-0-06-085962-6
Manufactured in China

First Printing, 2006

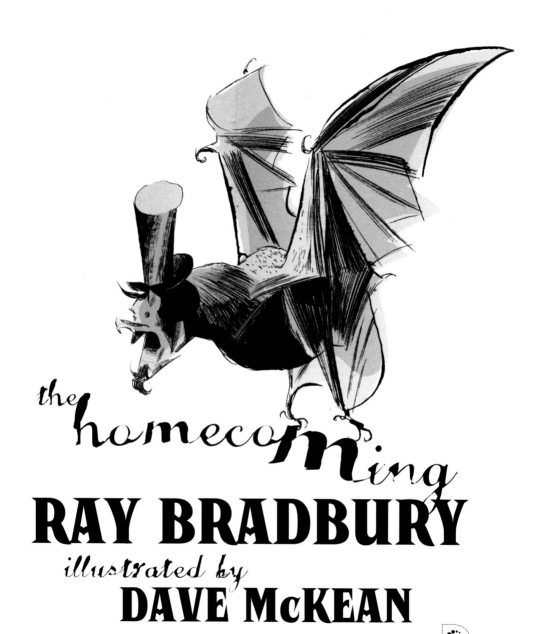

the homecoming

RAY BRADBURY

illustrated by
DAVE McKEAN

COLLINS|DESIGN
An Imprint of HarperCollinsPublishers

This book is dedicated to the expansive, outrageous, delightful monster that is Oscar Grillo. With thanks for the daily drawings...

DM

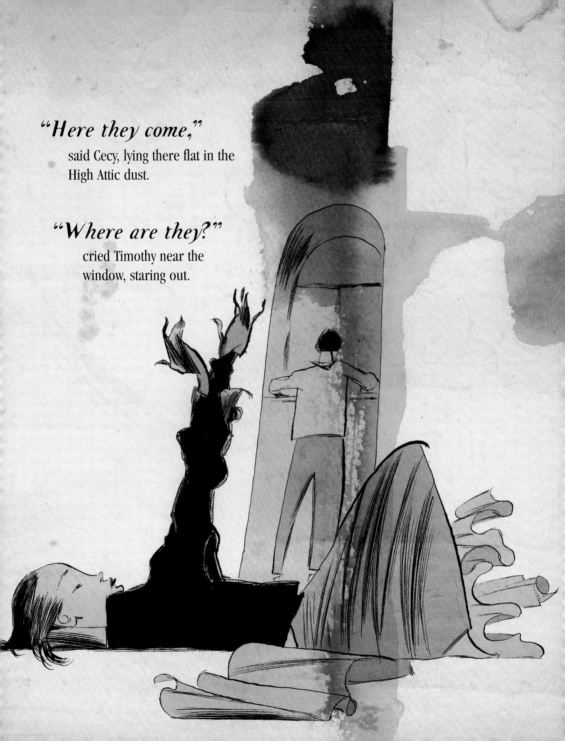

"Here they come,"
said Cecy, lying there flat in the
High Attic dust.

"Where are they?"
cried Timothy near the
window, staring out.

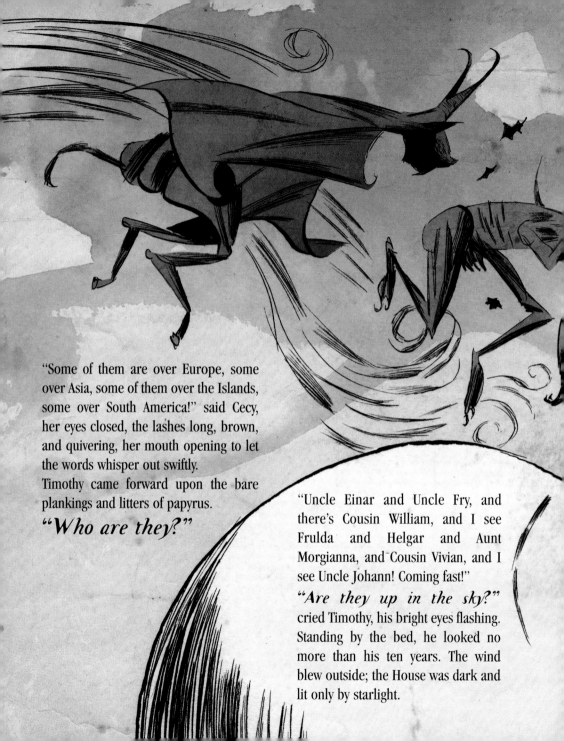

"Some of them are over Europe, some over Asia, some of them over the Islands, some over South America!" said Cecy, her eyes closed, the lashes long, brown, and quivering, her mouth opening to let the words whisper out swiftly.

Timothy came forward upon the bare plankings and litters of papyrus.

"Who are they?"

"Uncle Einar and Uncle Fry, and there's Cousin William, and I see Frulda and Helgar and Aunt Morgianna, and Cousin Vivian, and I see Uncle Johann! Coming fast!"

"Are they up in the sky?" cried Timothy, his bright eyes flashing. Standing by the bed, he looked no more than his ten years. The wind blew outside; the House was dark and lit only by starlight.

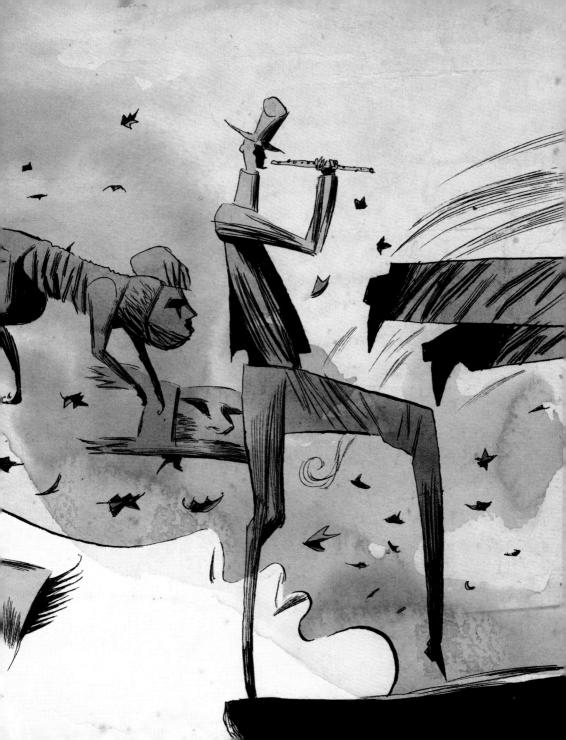

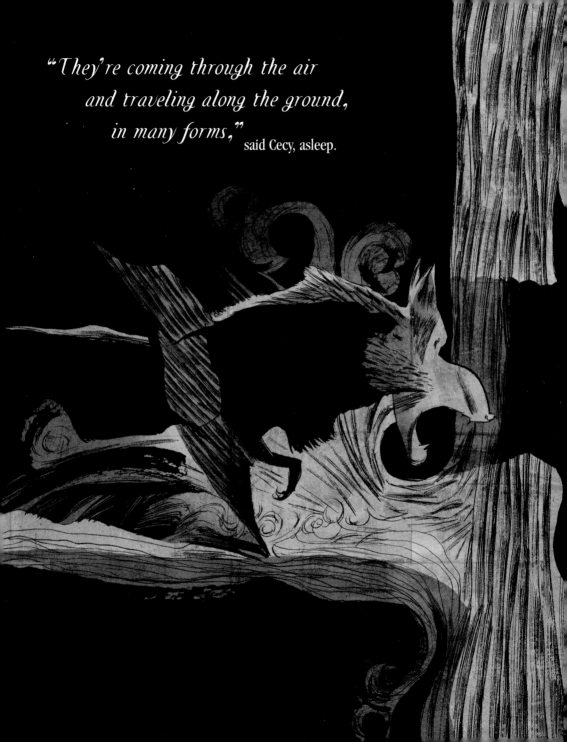

"They're coming through the air
and traveling along the ground,
in many forms," said Cecy, asleep.

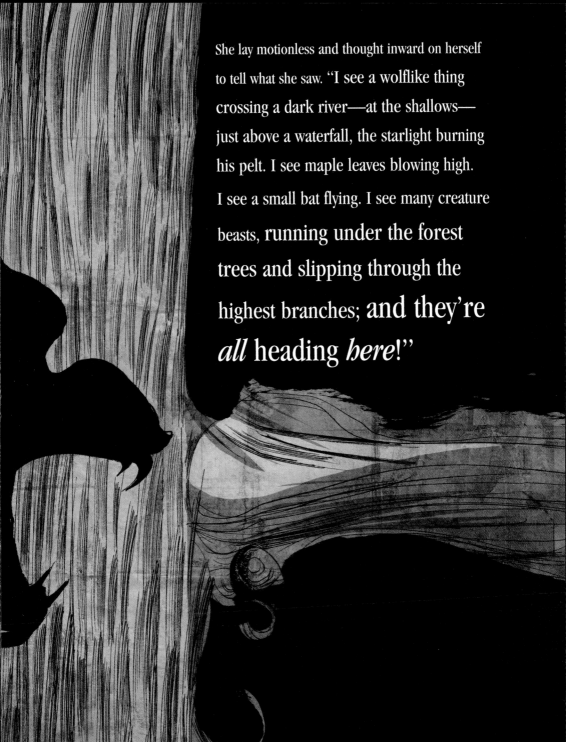

She lay motionless and thought inward on herself to tell what she saw. "I see a wolflike thing crossing a dark river—at the shallows— just above a waterfall, the starlight burning his pelt. I see maple leaves blowing high. I see a small bat flying. I see many creature beasts, running under the forest trees and slipping through the highest branches; and they're *all* heading *here*!"

"Will they be here in time?"

The spider on Timothy's lapel swung like a black pendulum, excitedly dancing.

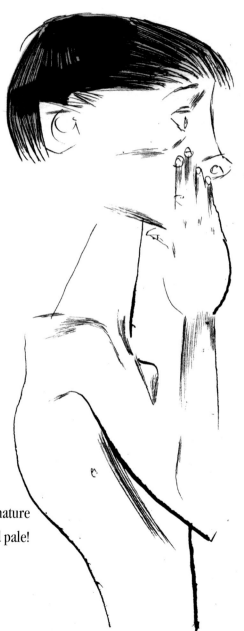

He leaned over his sister.
"In time for the Homecoming?"
"Yes, yes, Timothy!" Cecy stiffened.
"Go! Let me travel in the places I love!"

"Thanks!" In the hall, he ran to his room to make his bed. He had awakened at sunset, and as the first stars had risen, he had gone to let his excitement run with Cecy.

The spider hung on a silvery lasso about his slender neck as he washed his face. "Think, Arach, tomorrow night! All Hallows' Eve!"
He lifted his face to the mirror, the only mirror in the House, his mother's concession to his **"illness."**

Oh, if only he were not so afflicted!

He gaped his mouth to show the poor teeth nature had given him. Corn kernels, round, soft, and pale! And his canines? Unsharpened flints!

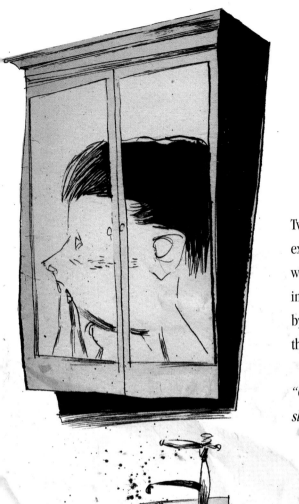

Twilight was done. He lit a candle, exhausted. This past week the whole small Family had lived as in their old countries, sleeping by day, rousing at sunset to hurry the preparation.

"Oh, Arach, Arach, if only I could really sleep days, like all the rest!"

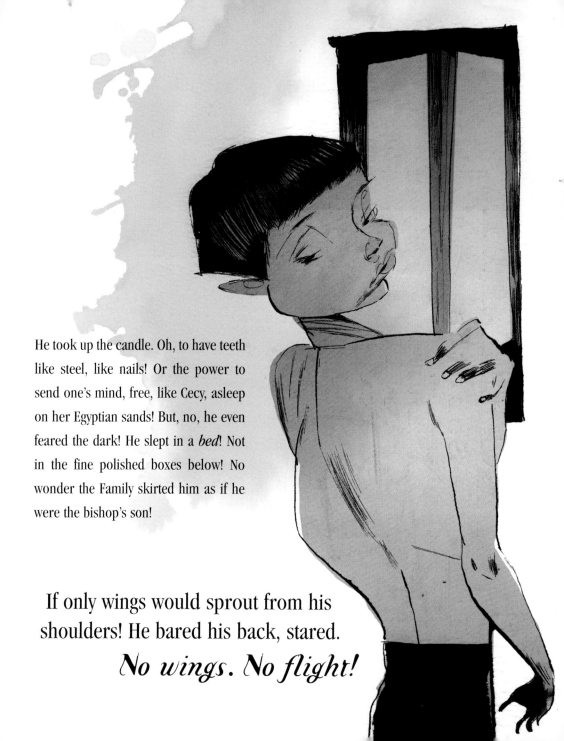

He took up the candle. Oh, to have teeth like steel, like nails! Or the power to send one's mind, free, like Cecy, asleep on her Egyptian sands! But, no, he even feared the dark! He slept in a *bed*! Not in the fine polished boxes below! No wonder the Family skirted him as if he were the bishop's son!

If only wings would sprout from his shoulders! He bared his back, stared.
No wings. No flight!

Downstairs were slithering sounds of black crepe rising in all the halls, all the ceilings, every door! The scent of burning black tapers rose up the banistered stairwell with Mother's voice and Father's, echoing from the cellar.

"Oh, Arach, will they let me be, really be, in the party?" said Timothy.

The spider whirled at the end of its silk, alone to itself.
"Not just fetch toadstools and cobwebs, hang crepe, or cut pumpkins. But I mean run around, jump, yell, laugh, heck, be the party. Yes!?"

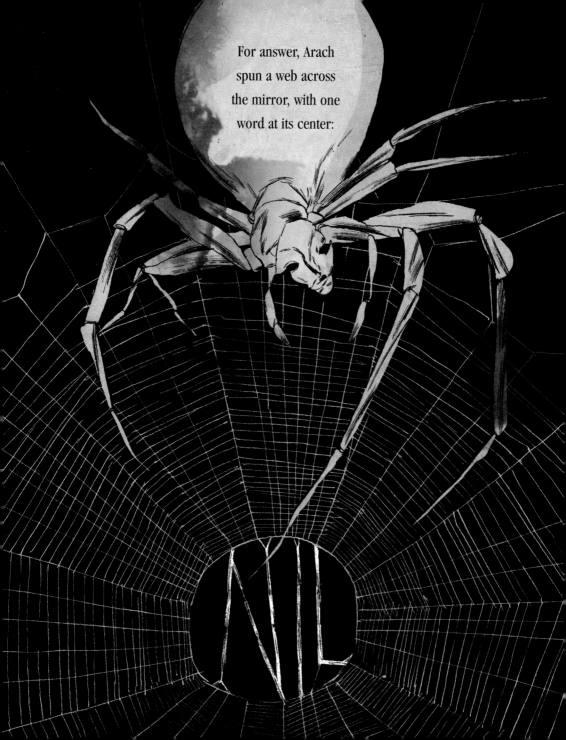

For answer, Arach
spun a web across
the mirror, with one
word at its center:

All through the House below, the one and only cat ran in a frenzy, the one and only mouse in the echoing wall said the same in nervous graffiti sounds, as if to cry:

"The Homecoming!" everywhere.

Timothy climbed back to Cecy, who slept deep.

"*Where are you now, Cecy?*" he whispered.

"*In the air? On the ground?*"

"Soon," Cecy murmured.

"Soon," Timothy beamed. "*All Hallows! Soon!*"

He backed off studying the shadows of strange birds and loping beasts in her face.

At the open cellar door, he smelled the moist earth air rising.

"Father?"

"Here!" Father shouted. "On the double!"

Timothy hesitated long enough to stare at a thousand shadows blowing on the ceilings, promises of arrivals, then he plunged into the cellar.

Father stopped polishing a long box. He gave it a thump.

"Shine this up for Uncle Einar!"

Timothy stared.

"*Uncle Einar's big! Seven feet?*"

"*Eight!*"

Timothy made the box shine. "And two hundred and sixty pounds?"

Father snorted. "Three hundred! And inside the box?"

"Space for *wings*?" cried Timothy.

"Space," Father laughed, "for wings."

At nine o'clock Timothy leaped out in the October weather. For two hours in the now-warm, now-cold wind he walked the small forest collecting toadstools.

He passed a farm. "If only you knew what's happening at *our* House!" he said to the glowing windows. He climbed a hill and looked at the town, miles away, settling into sleep, the church clock high and round and white in the distance. You don't know, either, he thought.

And carried the toadstools home.

In the cellar ceremony was celebrated, with Father incanting the dark words, Mother's white ivory hands moving in the strange blessings, and all the Family gathered except Cecy, who lay upstairs.

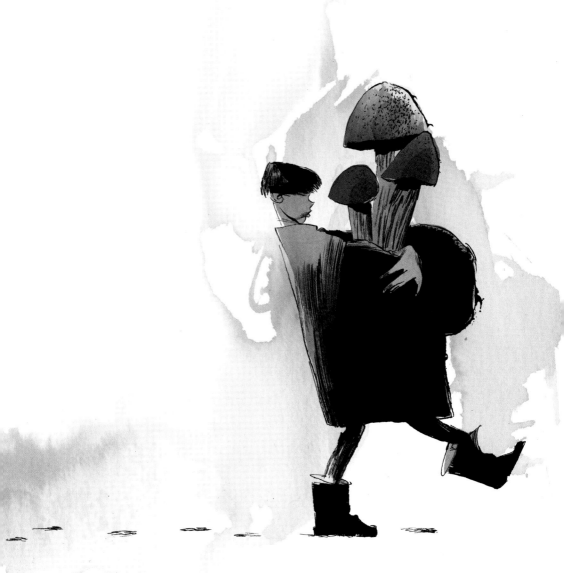

But Cecy was there.

 You saw her peering from now Bion's eyes,

 now Samuel's,

 now Mother's,

 and you felt a movement and now she rolled your eyes and was gone.

Timothy prayed to the darkness.

"Please, please, help me grow to be like them, the ones'll soon
be here, who never grow old, can't die, that's what they say,
can't die, no matter what, or maybe they died a long time ago
but Cecy calls, and Mother and Father call, and Grandmère
who only whispers, and now they're coming and I'm nothing,
not like them who pass through walls and live in trees or live
underneath until seventeen-year rains flood them up and out,
and the ones who run in packs, let *me* be one! If they live for-
ever, why not me?"

" *Forever,* " Mother's voice echoed, having heard.
"Oh, Timothy, there must be a way. Let us see! And now—"

The windows rattled. Grandmère's sheath of linen papyrus rustled.
Deathwatch beetles in the walls ran amok, ticking.

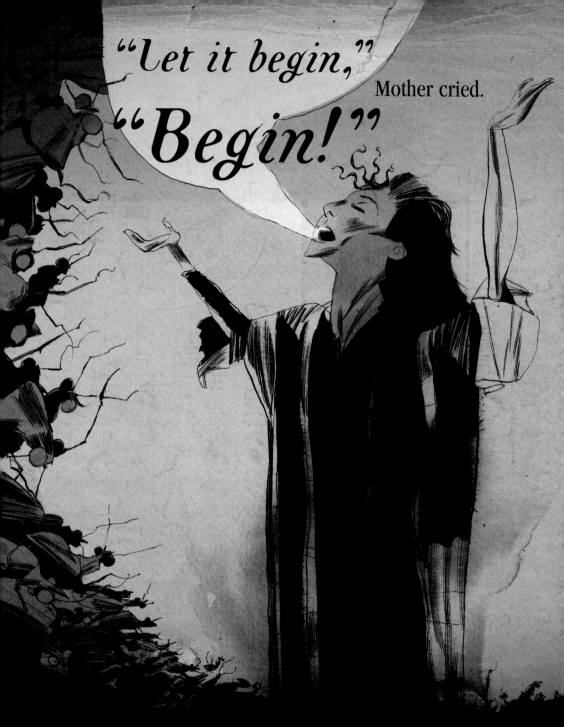

And the wind began.

It swarmed the world like a great beast unseen, and the whole world heard it pass in a season of grief and lamentation, a dark celebration of the stuffs it carried to disperse, and all of it funneling upper Illinois.

In tidal sweeps and swoons of sound, it robbed the graves of dust from stone angels' eyes, vacuumed the tombs of spectral flesh, seized funeral flowers with no names,

shucked druid trees to toss the leaf-harvest high in a dry downpour, a battalion of shorn skins and fiery eyes that burned crazily in oceans of ravening clouds that tore themselves to flags of welcome to pace the occupants of space as they grew in numbers to sound the sky with such melancholy eruptions of lost years that a million farmyard sleepers waked with tears on their faces wondering if it had rained in the night and no one had foretold,

and on the storm-river across the sea which roiled at this gravity of leave-taking and arrival until, with a flurry of leaves and dust commingled, it hovered in circles over the hill and the House and the welcoming party and Cecy above all, who in her attic, a slumberous totem on her sands, beckoned with her mind and breathed permission.

Timothy from the highest roof sensed a single blink of Cecy's eyes and— The windows of the House flew wide, a dozen here, two dozen there, to suck the ancient airs.

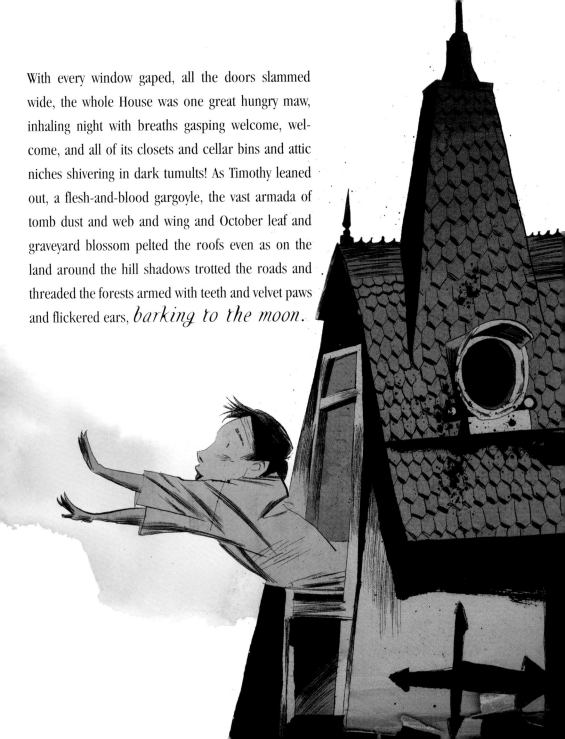

With every window gaped, all the doors slammed wide, the whole House was one great hungry maw, inhaling night with breaths gasping welcome, welcome, and all of its closets and cellar bins and attic niches shivering in dark tumults! As Timothy leaned out, a flesh-and-blood gargoyle, the vast armada of tomb dust and web and wing and October leaf and graveyard blossom pelted the roofs even as on the land around the hill shadows trotted the roads and threaded the forests armed with teeth and velvet paws and flickered ears, *barking to the moon.*

And this confluence of air and land struck the House through every window, chimney, and door.

Things that flew fair or in crazed jags, that walked upright or jogged on fours or loped like crippled shades, evicted from some funeral ark and bade farewell by a lunatic blind Noah, all teeth and no tongue, brandishing a pitchfork and fouling the air.

So all stood aside as the flood of shadow and cloud and rain that talked in voices filled the cellar, stashed itself in bins marked with the years they had died but to rise again, and the parlor chairs were seated with aunts and uncles with odd genetics and the kitchen crone had helpers who walked more strangely than she, as more aberrant cousins and long-lost nephews and peculiar nieces shambled or stalked or flew into pavanes about the ceiling chandeliers and feeling the rooms fill below and the grand concourse of unnatural survivals of the unfit, as it was later put, made the pictures tilt on the walls, the mouse run wild in the flues as Egyptian smokes sank, and the spider on Timothy's neck take refuge in his ear, crying an unheard "*sanctuary*"

as Timothy ducked in and stood admiring Cecy, this slumberous marshal of the tumult, and then leaped to see Great Grandmère, linens bursting with pride, her lapis lazuli eyes all enflamed, and then falling downstairs amidst heartbeats and bombardments of sounds as if he fell through an immense birdcage where were locked an aviary of midnight creatures all wing hastening to arrive but ready to leave until at last with a great roar and a concussion of thunder where there had been no lightning the last storm cloud shut like a lid upon the moonlit roof, the windows, one by one, crashed shut, the doors slammed, the sky was cleared, the roads empty.

And Timothy amidst it all,
stunned,
gave a great shout
of delight.
At which a
thousand shadows
turned.
Two thousand Beast
eyes burned yellow,
green,
and sulfurous gold.

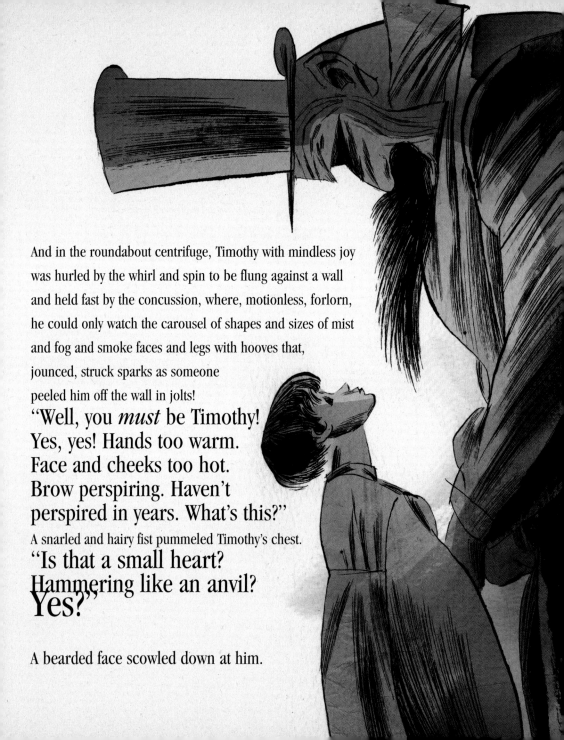

And in the roundabout centrifuge, Timothy with mindless joy
was hurled by the whirl and spin to be flung against a wall
and held fast by the concussion, where, motionless, forlorn,
he could only watch the carousel of shapes and sizes of mist
and fog and smoke faces and legs with hooves that,
jounced, struck sparks as someone
peeled him off the wall in jolts!
"Well, you *must* be Timothy!
Yes, yes! Hands too warm.
Face and cheeks too hot.
Brow perspiring. Haven't
perspired in years. What's this?"
A snarled and hairy fist pummeled Timothy's chest.
"Is that a small heart?
Hammering like an anvil?
Yes?"

A bearded face scowled down at him.

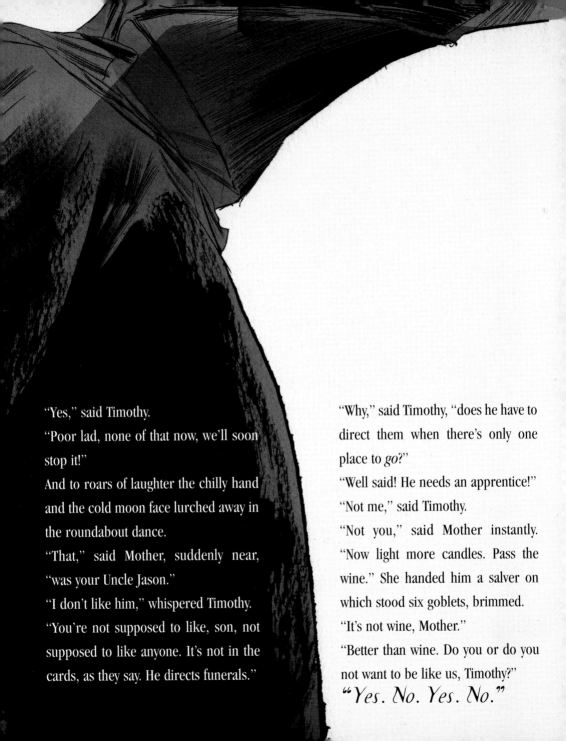

"Yes," said Timothy.

"Poor lad, none of that now, we'll soon stop it!"

And to roars of laughter the chilly hand and the cold moon face lurched away in the roundabout dance.

"That," said Mother, suddenly near, "was your Uncle Jason."

"I don't like him," whispered Timothy.

"You're not supposed to like, son, not supposed to like anyone. It's not in the cards, as they say. He directs funerals."

"Why," said Timothy, "does he have to direct them when there's only one place to *go*?"

"Well said! He needs an apprentice!"

"Not me," said Timothy.

"Not you," said Mother instantly. "Now light more candles. Pass the wine." She handed him a salver on which stood six goblets, brimmed.

"It's not wine, Mother."

"Better than wine. Do you or do you not want to be like us, Timothy?"

"Yes. No. Yes. No."

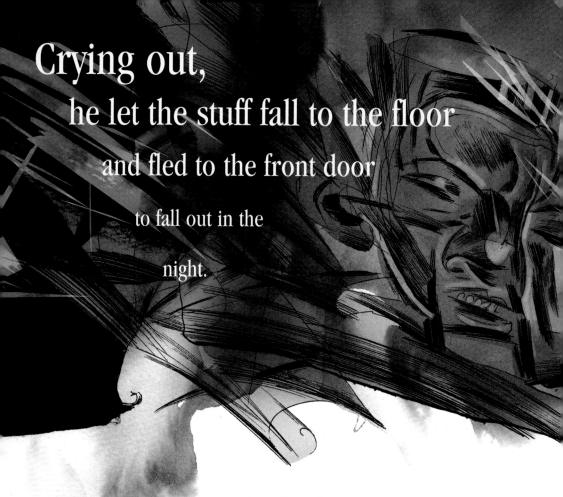

Crying out,

he let the stuff fall to the floor

and fled to the front door

to fall out in the

night.

Where a thunderous avalanche of wings fell down to clout his face, his arms, his hands. A vast confusion brushed his ears, banged his eyes, chopped his upraised fists as, in the terrible roar of this downfell burial he saw a dreadfully smiling face and cried, *"Einar! Uncle!"*

"Or even Uncle Einar!" shouted the face, and seizing him, threw him high in the night air where, suspended and shrieking, he was caught again as the man with wings leaped up to catch and whirl him, laughing.

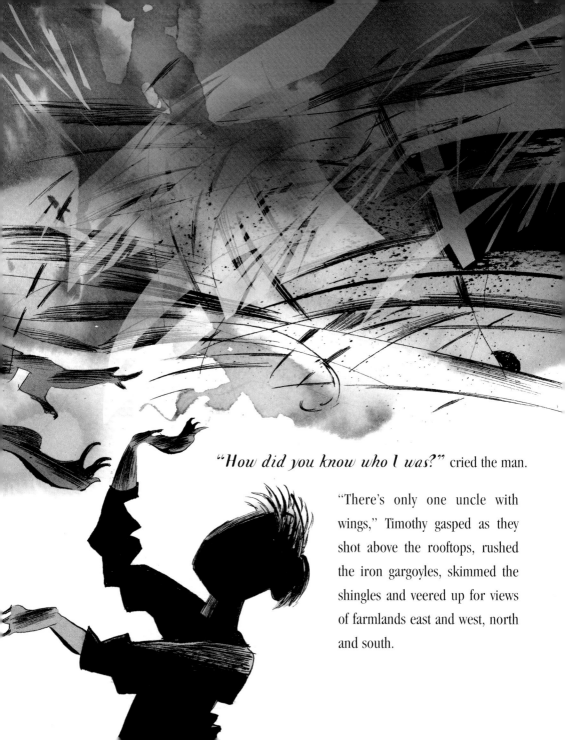

"How did you know who I was?" cried the man.

"There's only one uncle with wings," Timothy gasped as they shot above the rooftops, rushed the iron gargoyles, skimmed the shingles and veered up for views of farmlands east and west, north and south.

"FLY!

Timothy, fly!"

shouted the great bat-winged uncle.

"I am, I am!" gasped Timothy.

"No, really fly!"

And laughing, the good uncle tossed and Timothy fell, flapping his arms, and still fell, shrieking, to be caught again.

"Well, well, in time," said Uncle Einar. "Think. Wish. And with the wishing: *make!*"

Timothy shut his eyes, floating amidst the great flutter of pinions that filled the sky and blinded the stars. He felt small buds of fire in his shoulder blades and wished more and felt bumps grow and push to burst! Hell and damn. Damn and hell!

"In time," said Uncle Einar, guessing his thought.

"One day, or you're not my nephew! Quick!"

They skimmed the roof, peered into attic dunes where Cecy dreamed, seized an October wind that soared them to the clouds, and plummeted down, gently, to land upon the porch where two dozen shadows with mist for eyes welcomed them with a proper tumult and rainfall applause.

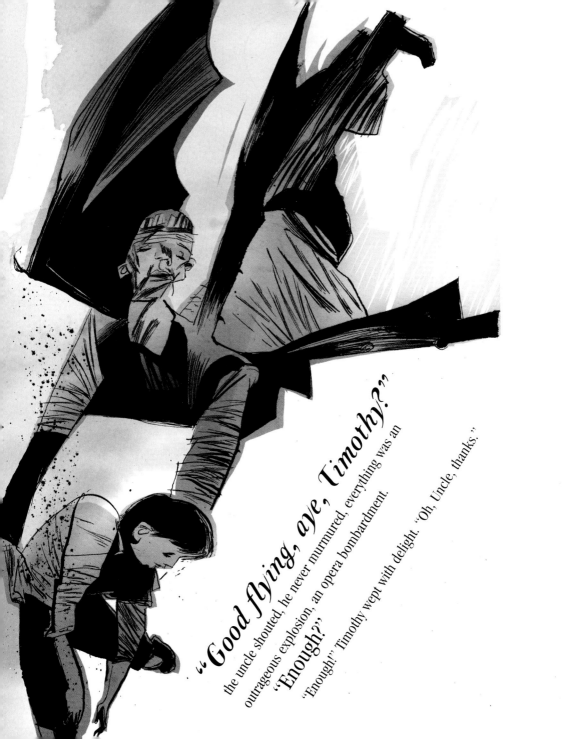

"*Good flying, aye, Timothy?*"

the uncle shouted, he never murmured, everything was an outrageous explosion, an opera bombardment. "Enough?"

"Enough!" Timothy wept with delight. "Oh, Uncle, thanks."

"His first lesson," Uncle Einar announced.

"Soon the air, the sky, the clouds, will be his as well as mine!"

More rainfall applause as Einar carried Timothy in to the dancing phantoms at the tables and the almost-skeletons at the feast. Smokes exhaled from the chimneys shapeless to assume shapes of remembered nephews and cousins, then ceased being smolders and took on flesh to be crushed in the orchestra of dancers and crowd the banquet spreads. Until a cock crowed on some distant farm. All stiffened as if struck. The wildness stilled. The smokes and mists and rain-shapes melted along the cellar steps to stash, lounge, and occupy the bins and boxes with brass-labeled lids. Uncle Einar, last of all, kettledrummed the air as he descended, laughing at some half-remembered death, perhaps his own, until he lay in the longest box of all and let his wings simmer to be tucked on each side of his laughs and with the last bat-web pinion safely appliquéd to his chest, shut his eyes, gave a nod, and the lid, so summoned, shut down on his laughs as if he were still in flight and the cellar was all silence and dark.

Timothy, in the cold dawn, was abandoned. For all were gone, all slept fearful of light. He was alone, and loving the day and the sun, but wishing somehow to love darkness and night as he crept back up through all the stairs of the House saying,

"Sleep," murmured Cecy, as he lay on the Egyptian sands beside her.

"Hear me. Sleep. Sleep."

And, obeying, he slept.

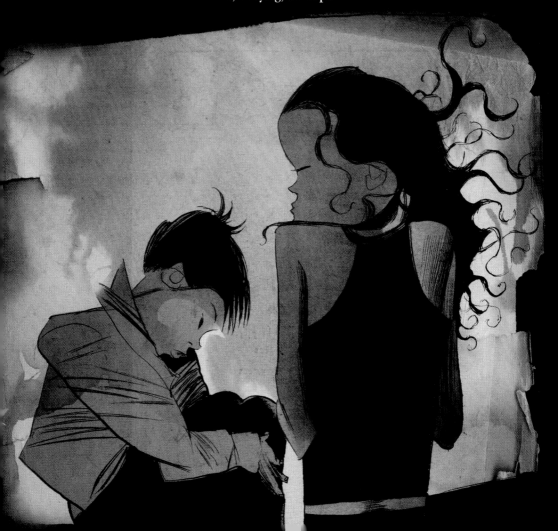

Sunset.

Three dozen long, hollow box-lids slammed wide. Three dozen filaments, cobwebs, ectoplasms swarmed up to pulsate and then—become.

Three dozen cousins, nephews, aunts, uncles melted themselves from the vibrant air, a nose here, a mouth here, a set of ears, some upraised hands and gesticulant fingers, waiting for legs to extend the feet to extrude, whereupon they stepped out and down on the cellar floor even as the strange casks popped wide to let forth not vintages but autumn leaves like wings and wings like autumn leaves which stormed footless up the stairs, while from down the vacuumed chimney flues blown forth in cindered smokes, tunes sounded from players invisible, and a rodent of incredible size chorded the piano and waited on applause.

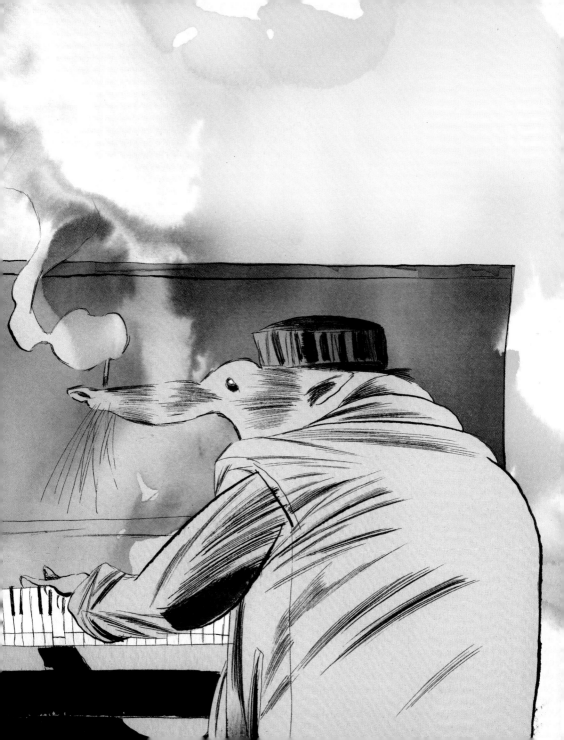

In the midst of which, Timothy was ricocheted from beast-child to dread relative in a volcanic roar so that at last, defeated, he yanked himself free and fled to the kitchen where something huddled against the flooded windowpanes. It sighed and wept and tapped continually, and suddenly he was outside, staring in, the rain beating, the wind chilling him, and all the candle darkness inside lost.

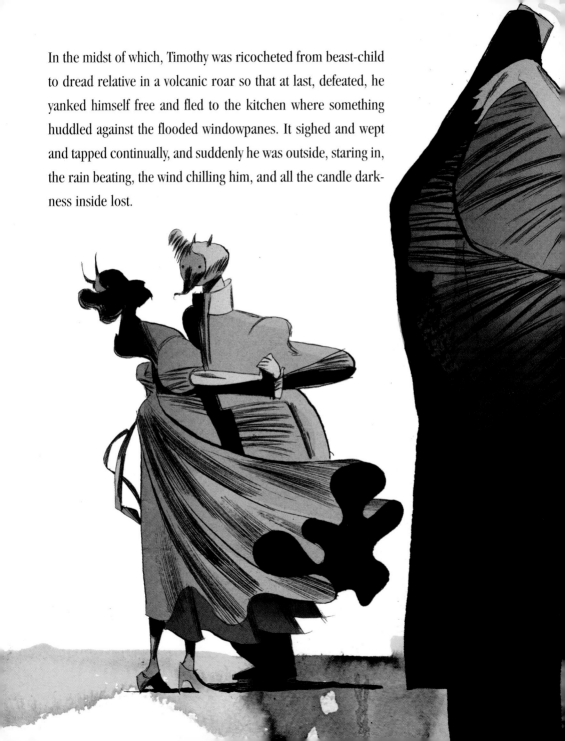

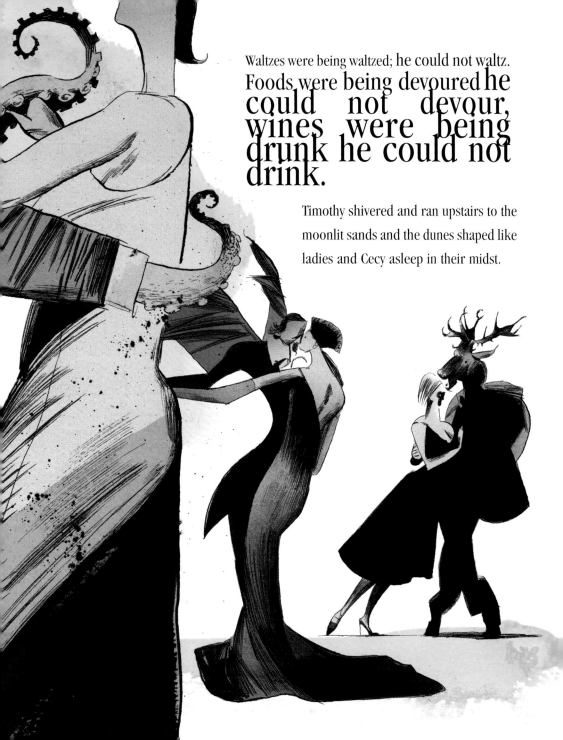

Waltzes were being waltzed; he could not waltz.
Foods were being devoured he could not devour, wines were being drunk he could not drink.

Timothy shivered and ran upstairs to the moonlit sands and the dunes shaped like ladies and Cecy asleep in their midst.

"Cecy,"

he called, softly.

"Where are you tonight?"

She said, "Far west. California. By a salt sea, near the mud pots and the steam and the quiet. I'm a farmer's wife sitting on a wooden porch. The sun's going down."

"What else, Cecy?"

"You can hear the mud pots whispering," she replied. "The mud pots lift little gray heads of steam, and the heads rip like rubber and collapse with a noise like wet lips. And there is a smell of sulfur and deep burning and old time. The dinosaur has been cooking here two billion years."

"Is he done yet, Cecy?"

Cecy's calm sleeper's lips smiled. "Quite done. Now it's full night here between the mountains. I'm inside this woman's head, looking out through the little holes in her skull, listening to the silence.

Planes fly like pterodactyls on huge wings. Further over, a steam shovel Tyrannosaurus stares at those loud reptiles flying high. I watch and smell the smells of prehistoric cookings. Quiet, quiet . . ."

"How long will you stay in her head, Cecy?"

"Until I've listened and looked and felt enough to change her life. Living in her isn't like living anywhere in the world. Her valley with her small wooden house is a dawn world. Black mountains enclose it with silence. Once in half an hour I see a car go by, shining its headlights on a small dirt road, and then silence and night. I sit on the porch all day, and watch the shadows run out from the trees, and join in one big night. I wait for my husband to come home. He never will. The valley, the sea, few cars, the porch, rocking chair, myself, the silence."

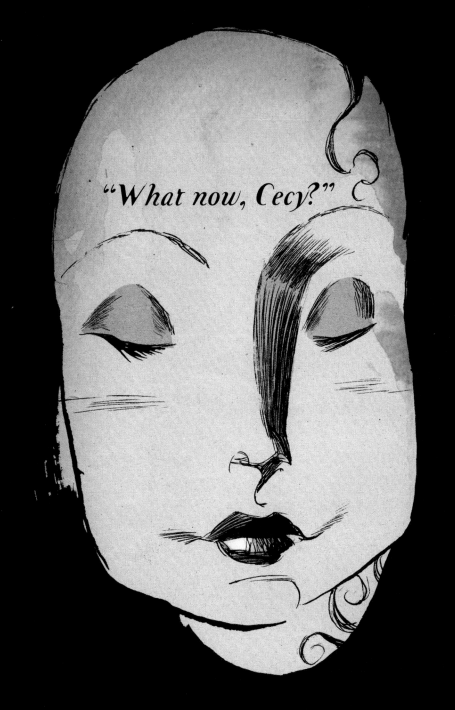

"I'm walking off the porch, toward the mud pots. Now the sulfur fumes are all around. A bird flies over, crying. I'm *in* that bird! And as I fly, inside my new small glass-bead eyes, I see that woman, below, take two steps out into the mud pots! I hear a sound as if a boulder has been dropped! I see a white hand, sinking in a pool of mud. The mud seals over. Now, I'm flying home!"

Something banged against the attic window.

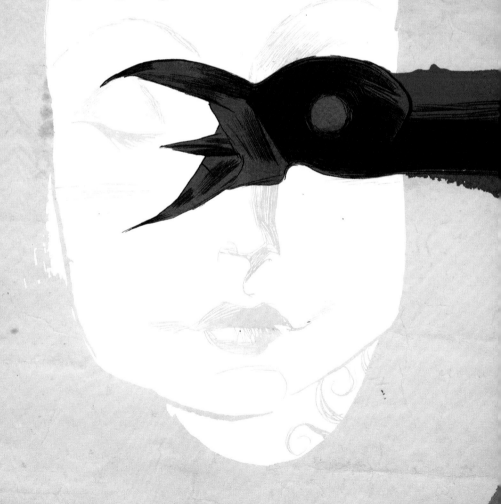

Cecy blinked.

"Now!" she laughed. *"I'm here!"*

Cecy let her eyes wander to find Timothy.
"Why are you upstairs instead of with the Homecoming?"
"Oh, Cecy!" he burst out. "I want to do something to make them see me, make me as fine as them, something to make me belong, and I thought *you* might—"
"Yes," she murmured. "Stand straight! Now, shut your eyes and think nothing,

nothing!"

He stood very straight and thought of nothing.
She sighed. "Timothy? Ready? Set?"
Like a hand into a glove, Cecy thrust in both ears.

"Go!"

"Everyone! Look!"

Timothy lifted the goblet of strange red wine, the peculiar vintage, so all could see. Aunts, uncles, cousins, nieces, nephews!

He drank it down.

He waved at his stepsister Laura, held her gaze, to freeze her in place.

Timothy pinned Laura's arms behind her, whispering. Gently, he bit her neck!

Candles blew out. Wind applauded the roof shingles. Aunts and uncles gasped.

Turning, Timothy crammed toadstools in his mouth, swallowed, then beat his arms against his hips and ran in circles. "Uncle Einar! Now I'll *fly*!"

At the top of the stairs, flapping, Timothy heard his mother cry, "No!"

"Yes!" Timothy hurled himself out, thrashing!

Halfway his wings exploded. Screaming, he fell.

To be caught by Uncle Einar.

Timothy squirmed wildly as a voice burst from his lips.

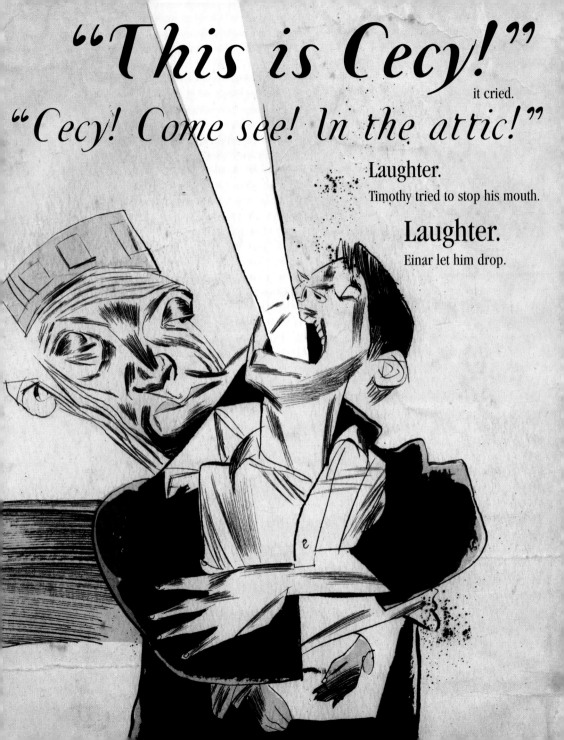

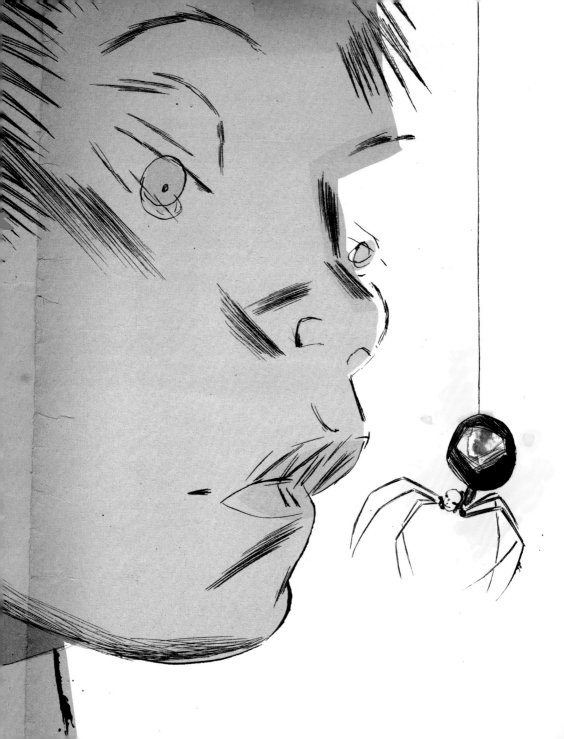

Running through the mob as they rushed up toward Cecy, Timothy kicked the front door wide and . . .

Flap! went the wine and toadstools, out into the cold autumn night.

"Cecy, I hate you, hate you!"

Inside the barn, in deep shadow, Timothy sobbed bitterly and thrashed in a stack of odorous hay. Then he lay still. From his blouse pocket, from the protection of the matchbox used as his retreat, the spider crawled forth and along Timothy's shoulder to his neck to climb to his ear. Timothy trembled. "No, no. Don't!"

The delicate touch of the feeler on his tympanum, small signals of large concern, made Timothy's crying cease.

The spider then traveled down his cheek, stationed itself beneath his nose, probing the nostrils as if to seek the melancholy in there, and then moved quietly up over the rim of his nose to sit, peering at Timothy, until he burst with laughter.

"Get, Arach! *Go*!"

In answer, the spider floated down and with sixteen delicate motions wove its filaments zigzag over Timothy's mouth which could only sound:

"Mmmmmm!"

Timothy sat up, rustling the hay.

Mouse was there in his blouse pocket, a small snug contentment to touch his chest and heart.

Anuba was there, curled in a soft round ball of sleep, all adream with many fine fish swimming in freshets of dream.

The land was painted with moonlight now. In the big House he could hear the ribald laughter as "Mirror, Mirror" was played with a huge mirror. Celebrants roared as they tried to identify those of themselves whose reflections did not, had not *ever*, and *never would* appear in a glass.

Timothy broke Arach's web on his lips:

"Now what?"

Falling to the floor, Arach scuttled swiftly toward the House, until Timothy trapped and tucked him back in his ear. "All right. Here we go, for fun, no matter what!" He ran. Behind, Mouse ran small, Anuba large. Half across the yard, a green tarpaulin fell from the sky and pinned him flat with silken wing. "Uncle!"

"Timothy." Einar's wings clamored like kettledrums. Timothy, a thimble, was set on Einar's shoulder. "Cheer up, nephew. How much richer things are for you. Our world is dead. All tombstone-gray. Life's best to those who live least, worth more per ounce, more per ounce!"

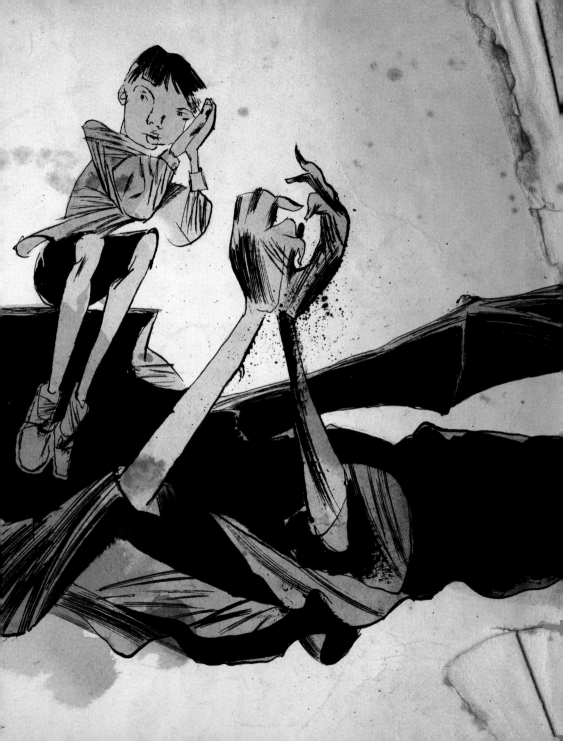

From midnight on, Uncle Einar soared him about the House, from room to room, weaving, singing, as they fetched

A Thousand Times Great Grandmère

down, wrapped in her Egyptian cerements, roll on roll of linen bandage coiled about her fragile archaeopteryx bones.

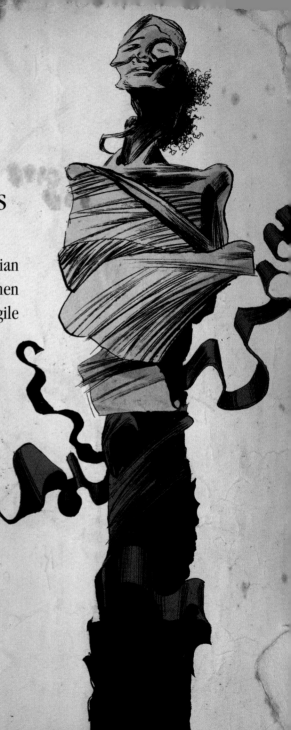

Silently she stood, stiff as a great loaf of Nile bread, her eyes flinting a wise, silent fire. At the predawn breakfast, she was propped at the head of the long table and suffered sips of incredible wines to wet her dusty mouth.

The wind rose,

the stars burned,

the dances quickened.

The many darknesses roiled, bubbled, vanished, reappeared.

"Coffins" was next.

Coffins, in a row, surrounded by marchers, timed to a flute. One by one coffins were removed. The scramble for their polished interiors eliminated two, four, six, eight marchers, until one coffin remained. Timothy circled it cautiously with his fey-cousin, Rob. The flute stopped. Gopher to hole, Timothy lunged at the box. Rob popped in first! Applause!

Laughter and chat.

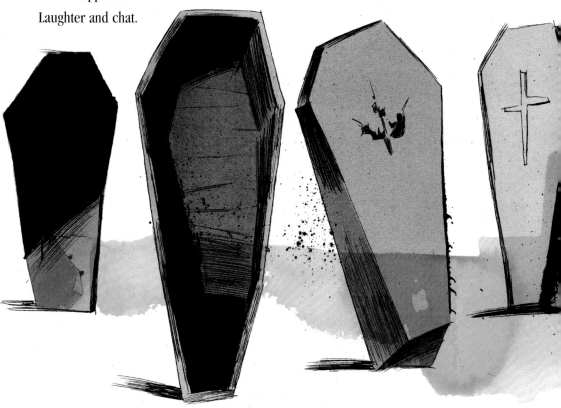

"How is Uncle Einar's sister? She of the wings."

"Lotte flew over Persia last week and was shot with arrows. A bird for a banquet. A bird!"

Their laughter was a cave of winds.

"And Carl?"

"The one who lives under bridges? Poor Carl. No place in all Europe for him. New bridges are rebuilt with Holy Water blessings! Carl is homeless. There are refugees tonight beyond counting."

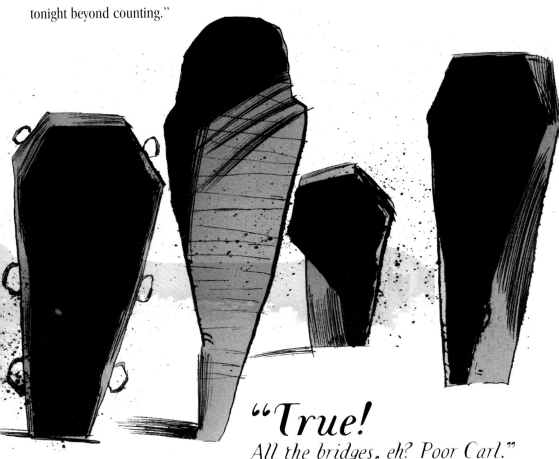

"*True!*
All the bridges, eh? Poor Carl."
"Listen!"
The party held still. Far off,
a town clock chimed 6 A.M.

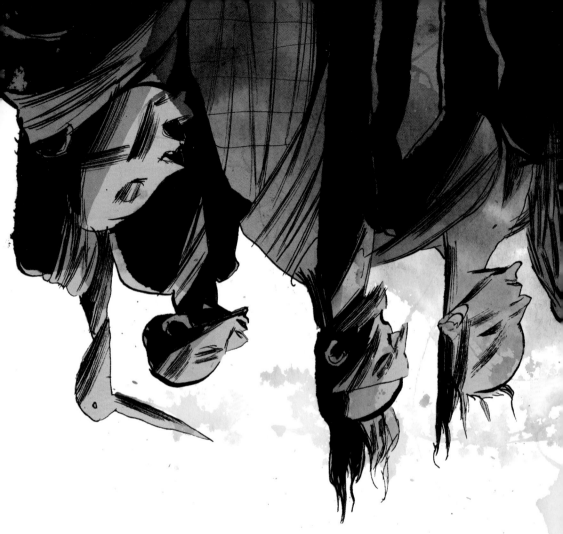

The Homecoming was done.

In time with the clock striking, a hundred voices began to sing songs that were centuries old. Uncles and aunts twined their arms around each other, circling, singing, and somewhere in the cold distance of morning the town clock stopped its chimes and was still.

Timothy sang.

He knew no words, no tune, yet he sang and the words and tune were pure, round and high and beautiful.

Finished, he gazed up to the High Attic of Egyptian sands and dreams.

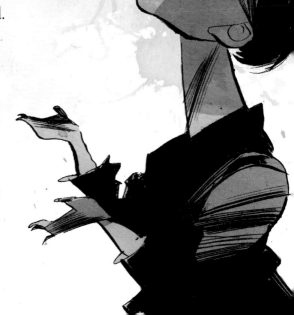

"Thanks, Cecy," he whispered.

A wind blew. Her voice echoed from his mouth, "Do you forgive me?"
Then he said, *"Cecy. Forgiven."*
Then he relaxed and let his mouth move as it wished, and the song continued, rhythmically, purely, melodiously.

Goodbyes were said in a great rustling. Mother and Father stood in grave happiness at the door to kiss each departing cheek. The sky, beyond, colored and shone in the east. A cold wind entered. They must all rise and fly west to beat the sun around the world. *Make haste, oh, make haste!*

Again Timothy listened to a voice in his head and said, "Yes, Cecy. I would like that. Thanks." And Cecy helped him into one body after another. Instantly, he felt himself inside an ancient cousin's body at the door, bowing and pressing lips to Mother's pale fingers, looking out at her from a wrinkled leather face. Then he stepped out into a wind that seized and blew him in a flurry of leaves away up over the awakening hills. With a snap, Timothy was behind another face, at the door, all farewells. It was Cousin William's face.

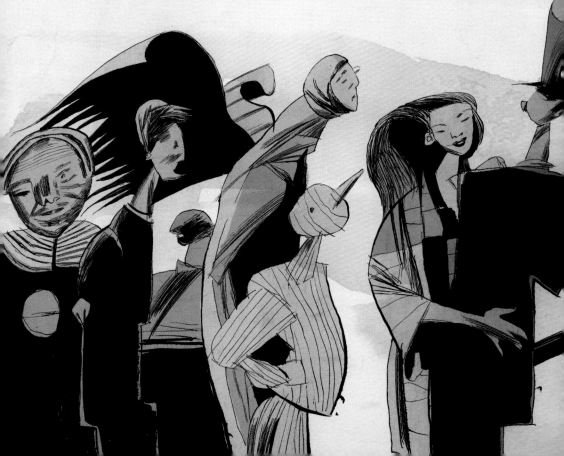

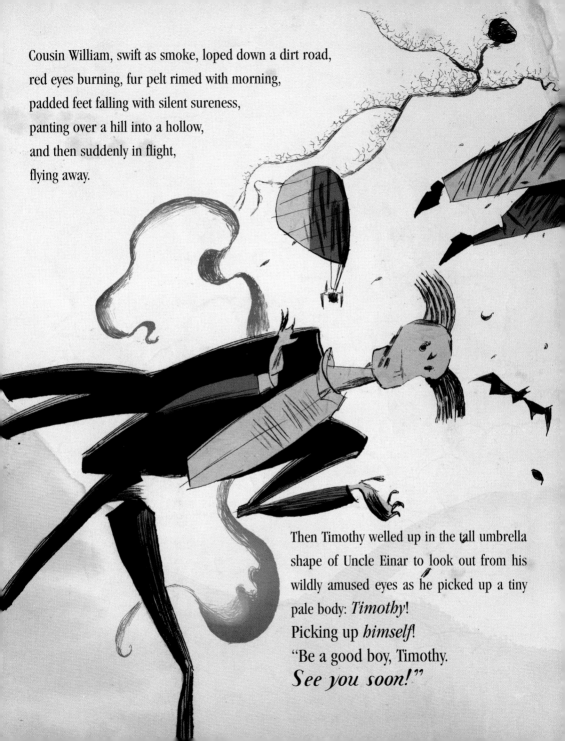

Cousin William, swift as smoke, loped down a dirt road,
red eyes burning, fur pelt rimed with morning,
padded feet falling with silent sureness,
panting over a hill into a hollow,
and then suddenly in flight,
flying away.

Then Timothy welled up in the tall umbrella
shape of Uncle Einar to look out from his
wildly amused eyes as he picked up a tiny
pale body: *Timothy*!
Picking up *himself*!
"Be a good boy, Timothy.
See you soon!"

Swifter than borne leaves, with a webbed thunder of wings, faster than the lupine thing of the country road, going so swiftly the earth's features blurred and the last stars tilted, like a pebble in Uncle Einar's mouth, Timothy flew, joined on half his flight. Then slammed back in his own flesh.

The shouting and the laughing faded and were almost lost. Everybody was embracing and crying and thinking how the world was becoming less a place for them. There had been a time when they had met every year, but now decades passed with no reconciliation. *"Don't forget, we meet in Salem in 2009!"* someone cried.

Salem. Timothy's numbed mind touched the word. Salem—2009. And there would be Uncle Fry and Grandma and Grandfather and A Thousand Times Great Grandmère in her withered cerements. And Mother and Father and Cecy and all the rest. But would *he* be alive that long?

With one last withering wind blast, away they all shot, so many scarves, so many fluttery mammals, so many seared leaves, so many wolves loping, so many whinings and clusterings, so many midnights and dawns and sleeps and wakenings.

Mother shut the door.

Father walked down into the cellar.

Timothy walked across the crepe-littered hall. His head was down, and in passing the party mirror he saw the pale mortality of his face. He shivered.

"Timothy," said Mother.

She laid a hand on his face. "Son,"
she said. "We love you. We all love
you. No matter how different you are,
no matter if you leave us one day."
She kissed his cheek. "And if
and when you die your bones
will lie undisturbed, we'll see
to that, you'll lie at ease forever,
and I'll come see you every All
Hallows' Eve and tuck you in more
secure."

*The halls echoed
to polished lids
creaking and
slamming shut.*

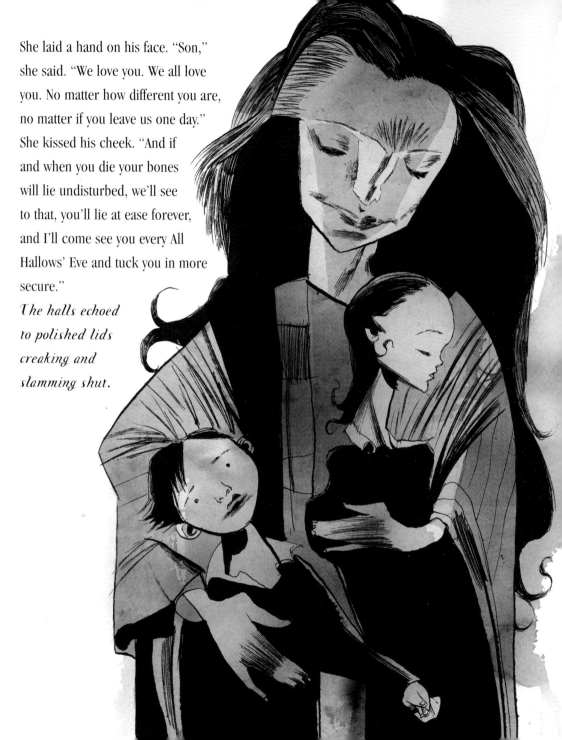

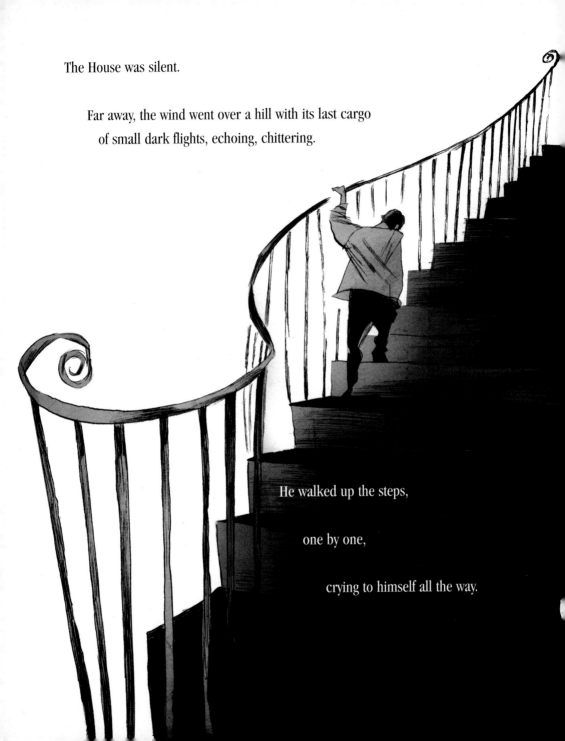

The House was silent.

Far away, the wind went over a hill with its last cargo
of small dark flights, echoing, chittering.

He walked up the steps,

one by one,

crying to himself all the way.